Large Print
Colour & Frame

Calm

31 relaxing colouring
pages to enjoy

Published by Richardson Publishing Limited.
www.richardsonpublishing.com

10 9 8 7 6 5 4 3 2 1

© Richardson Publishing Limited 2023.

All illustrations and typesetting by Clarity Media Ltd.

Cover design by Hannah Wadham.

ISBN 978-1-913602-37-6

Printed and bound by Bell & Bain Ltd, 303 Burnfield Road, Thornliebank, Glasgow G46 7UQ.

If you would like to comment on any aspect of this book, please contact us at:

E-mail: puzzles@richardsonpublishing.com

Follow us and @ us to share your artwork!

🐦 @puzzlesandgames
📷 @richardsonpuzzlesandgames
📘 @richardsonpuzzlesandgames
▶️ @richardsonpuzzlesandgames
♪ @richardsonpuzzlesngames

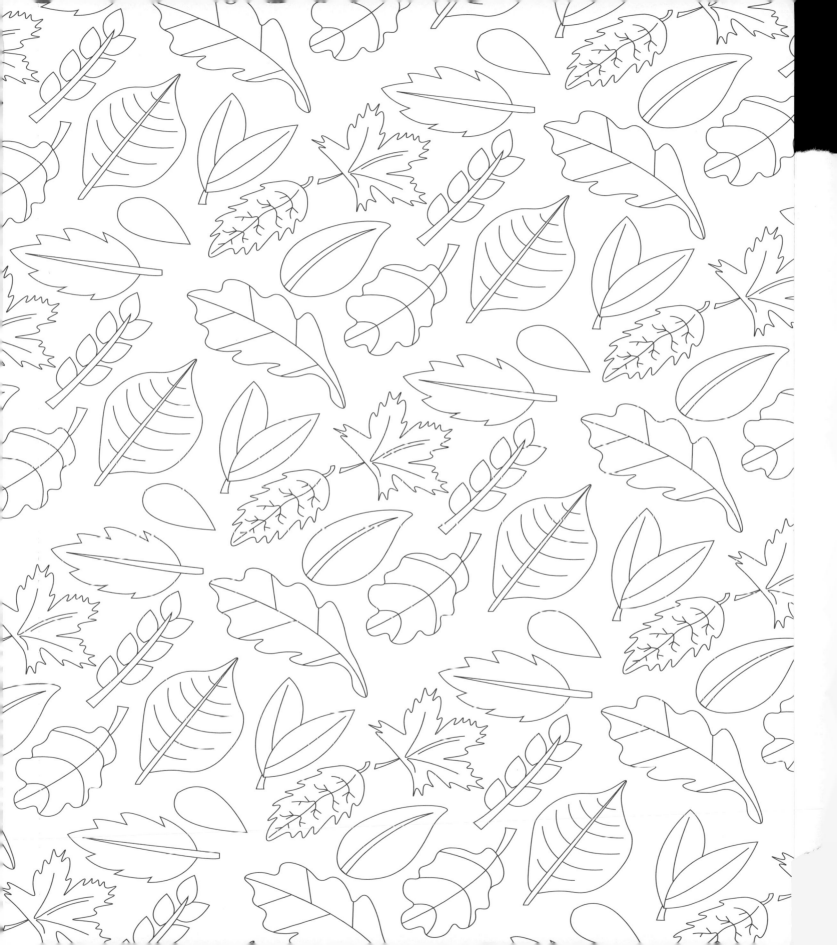

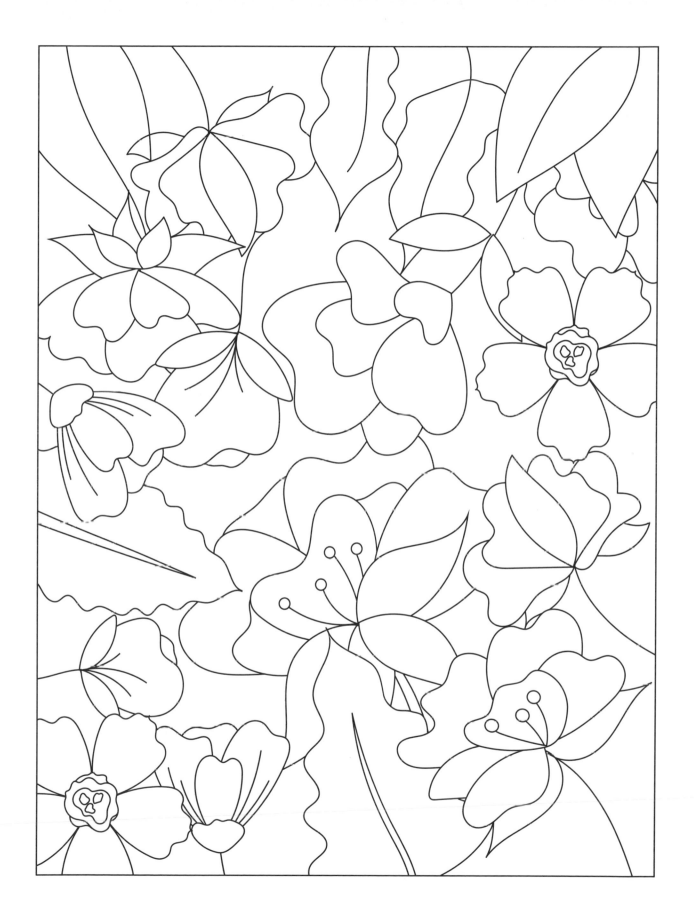

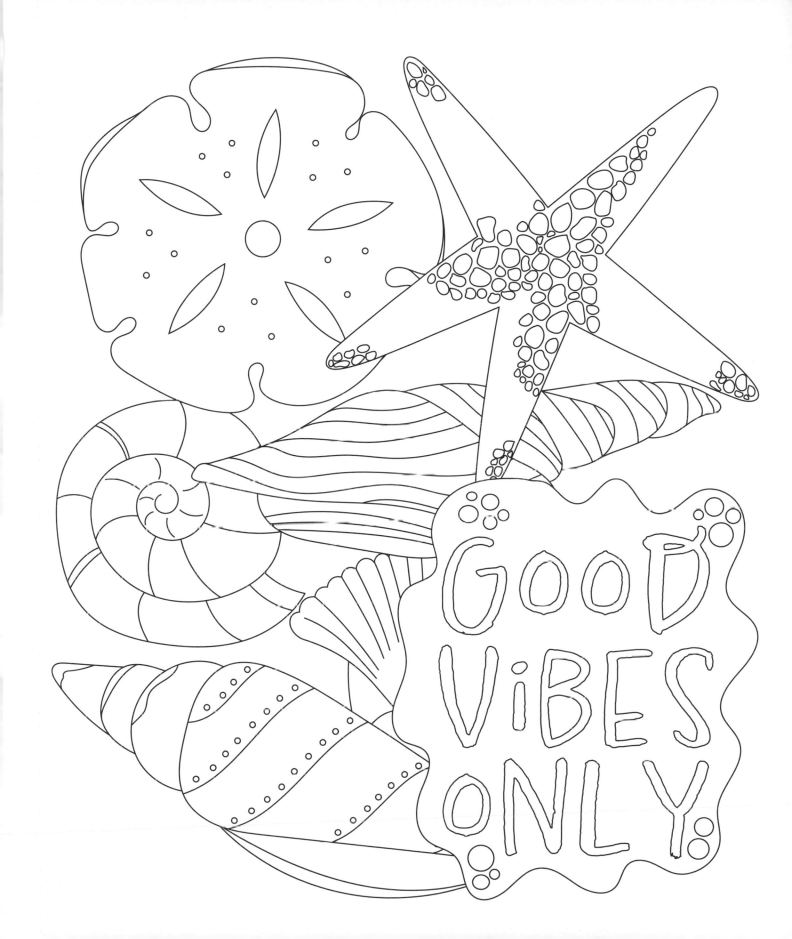

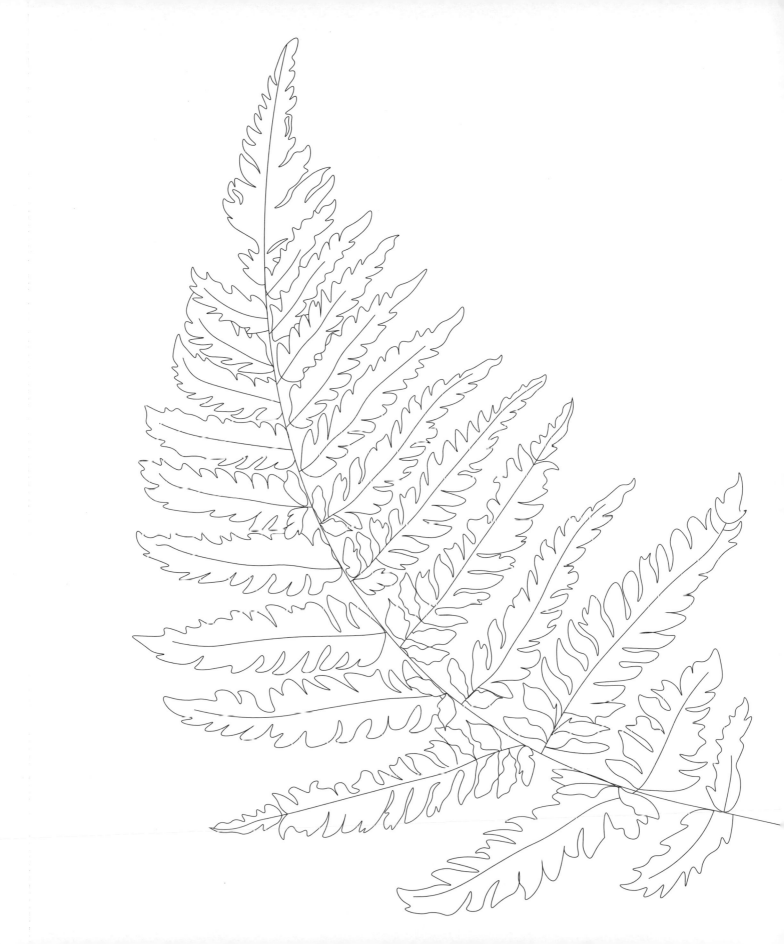

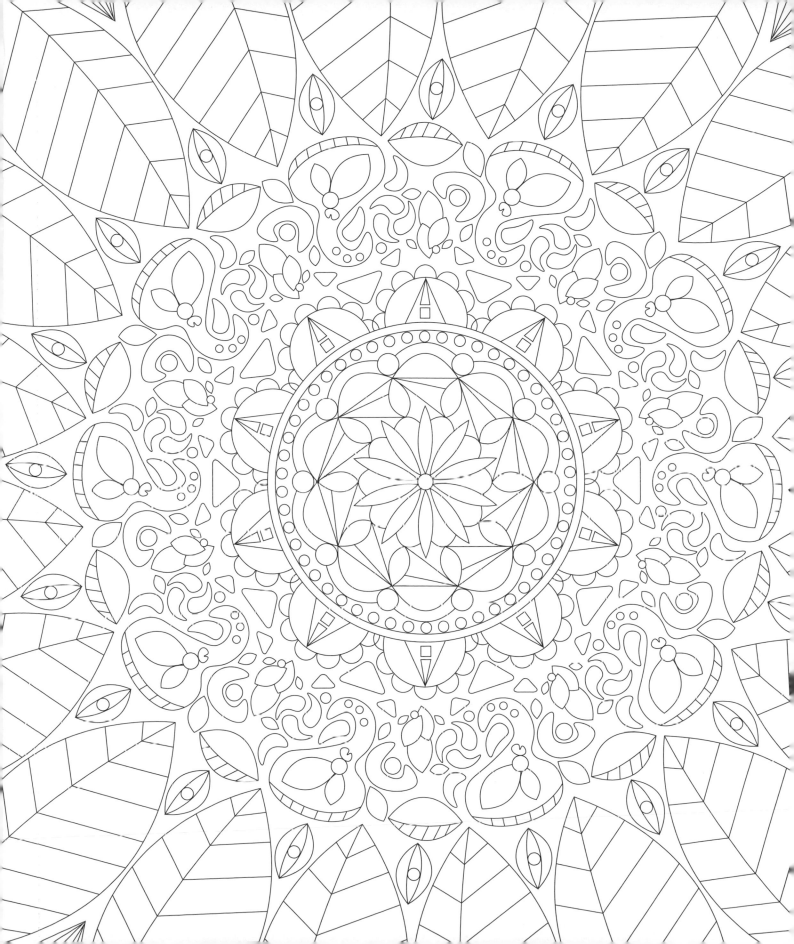

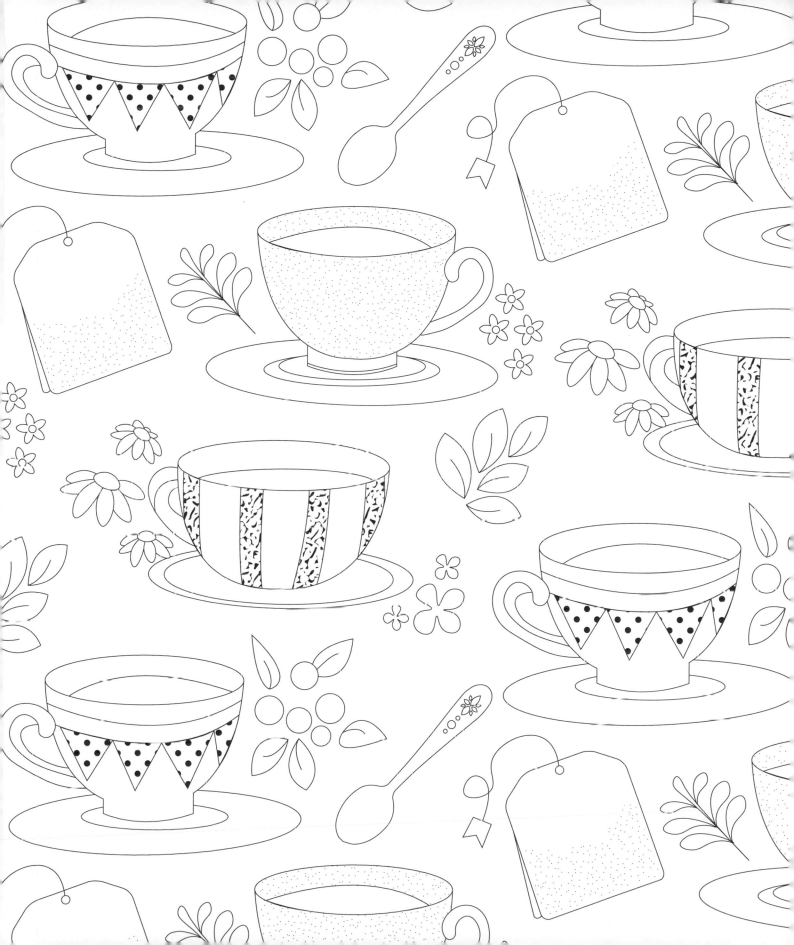

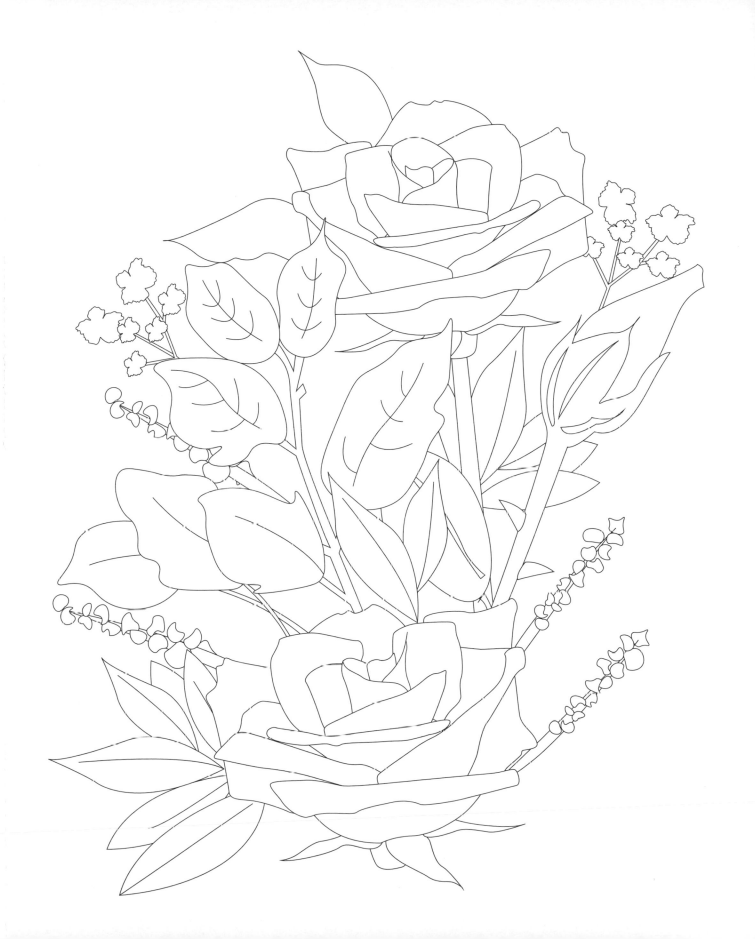

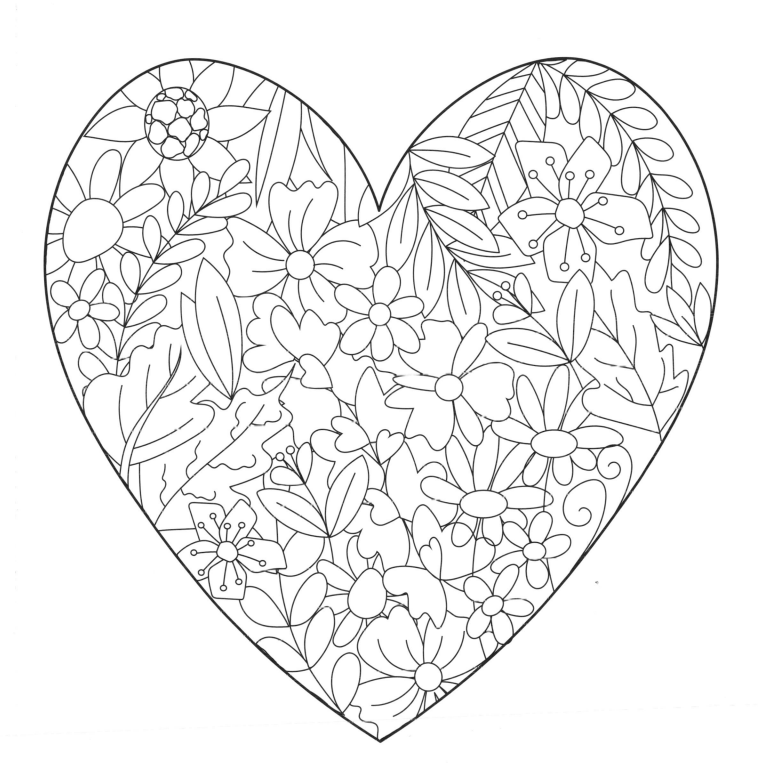

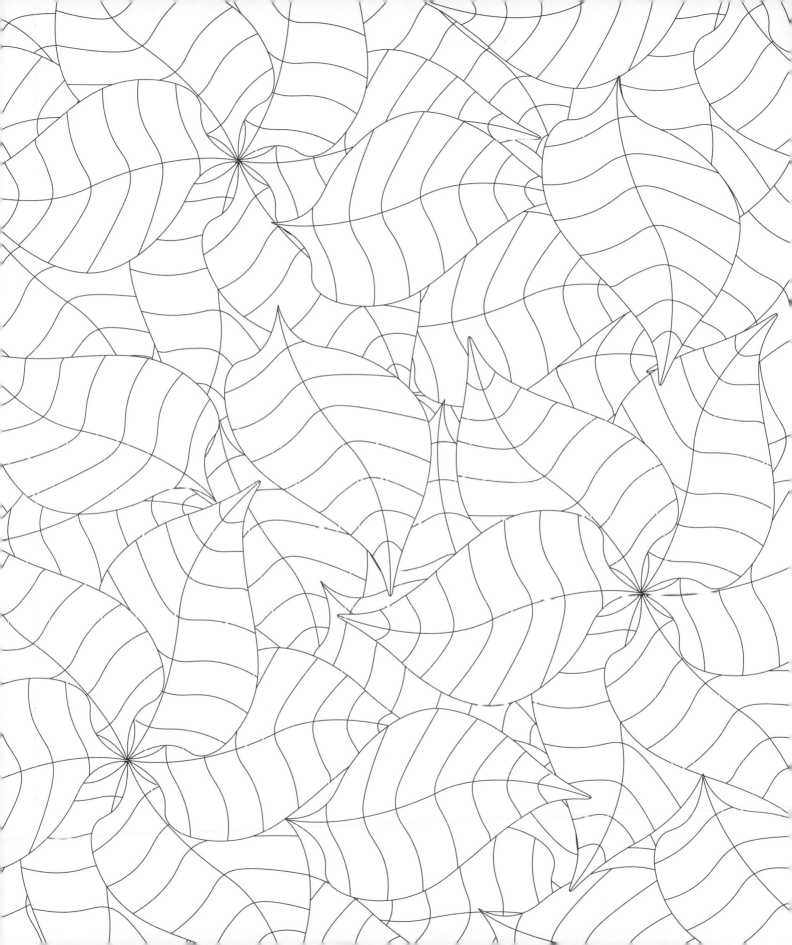

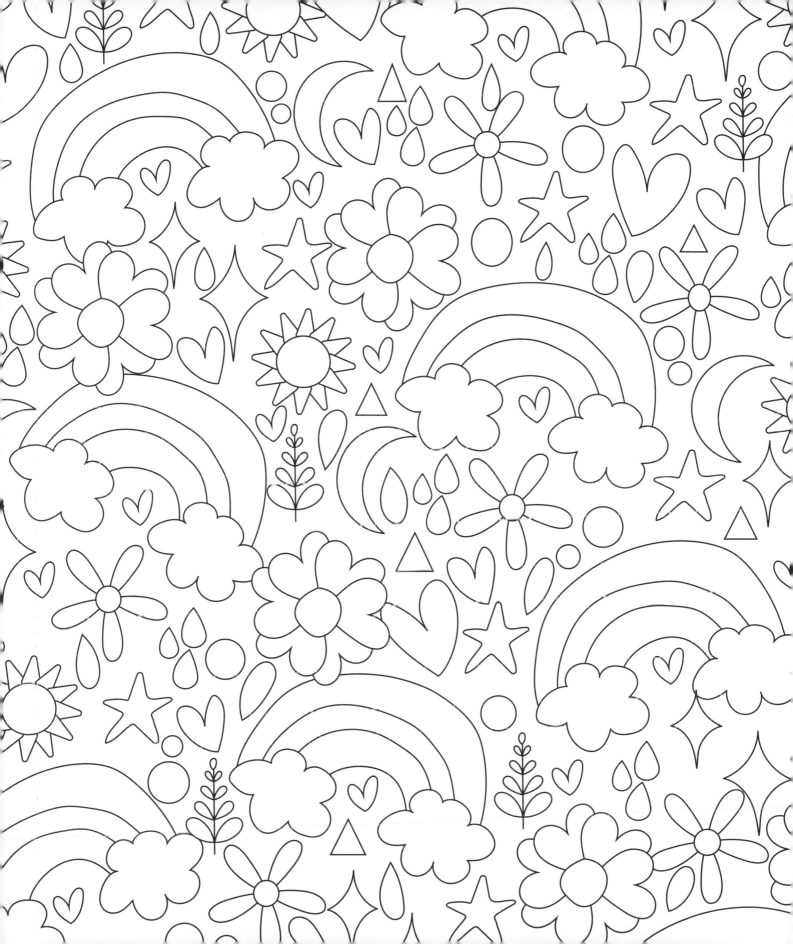

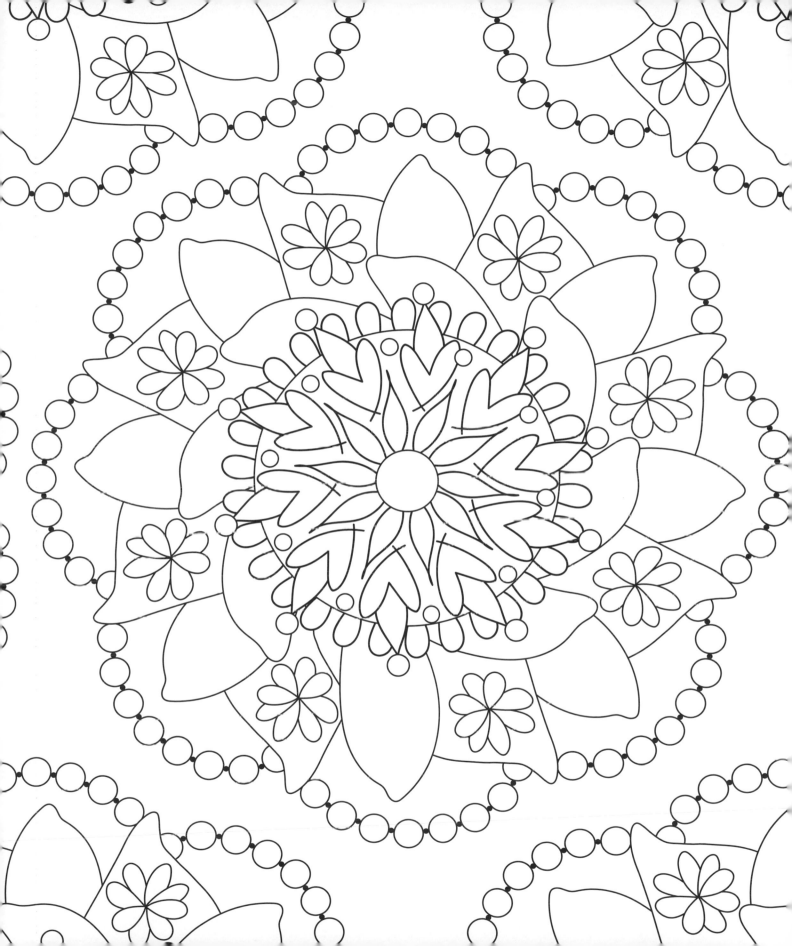

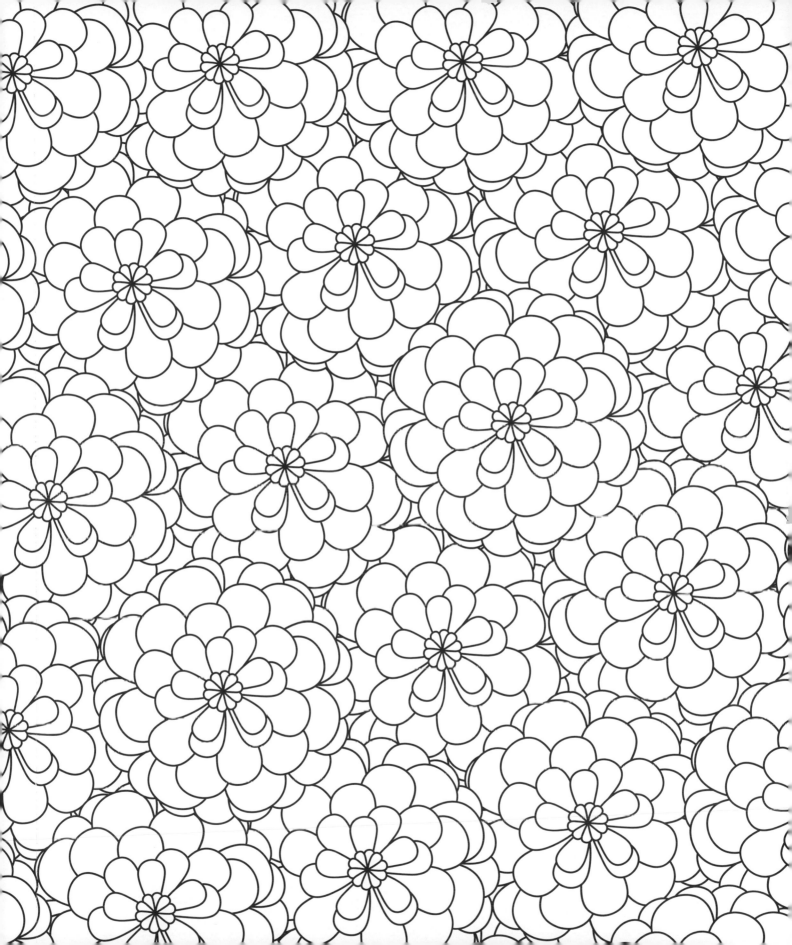

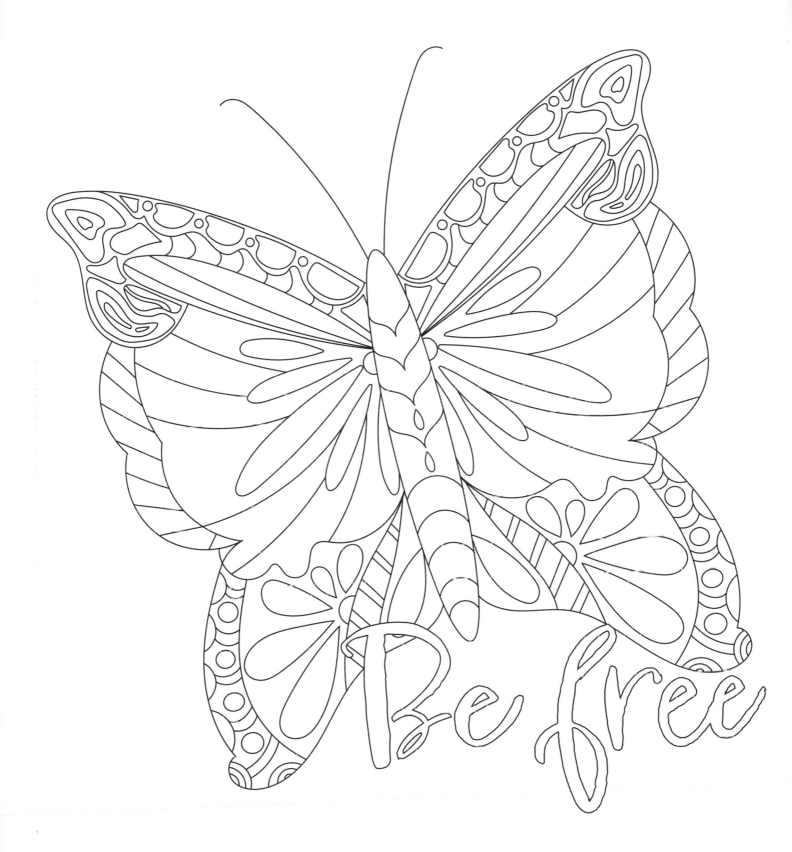

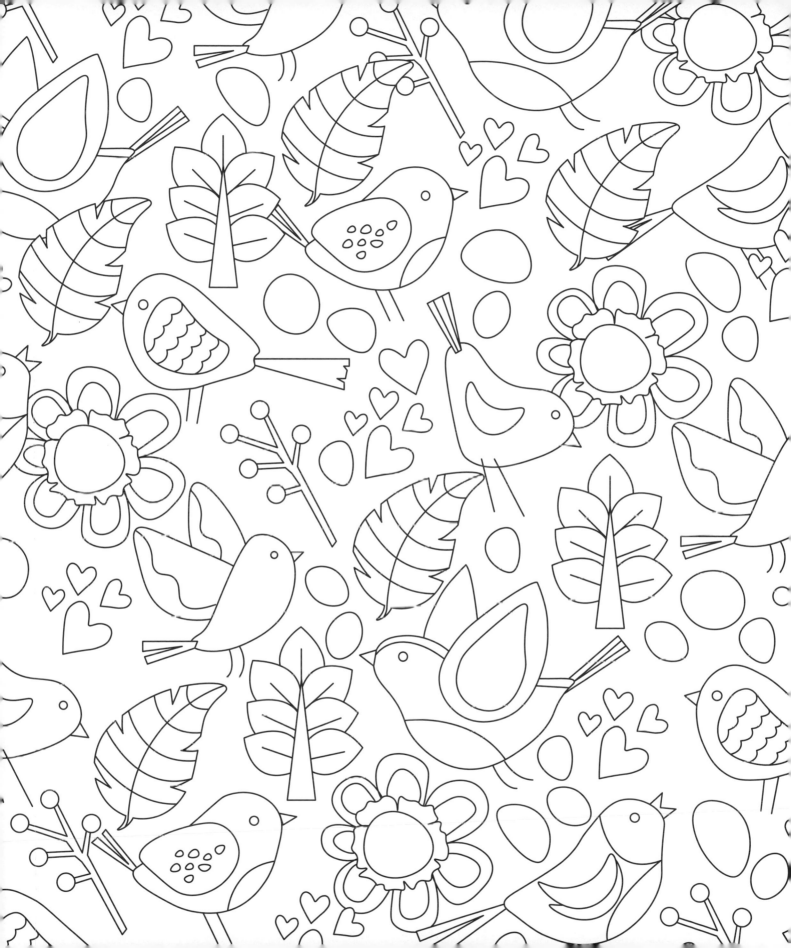

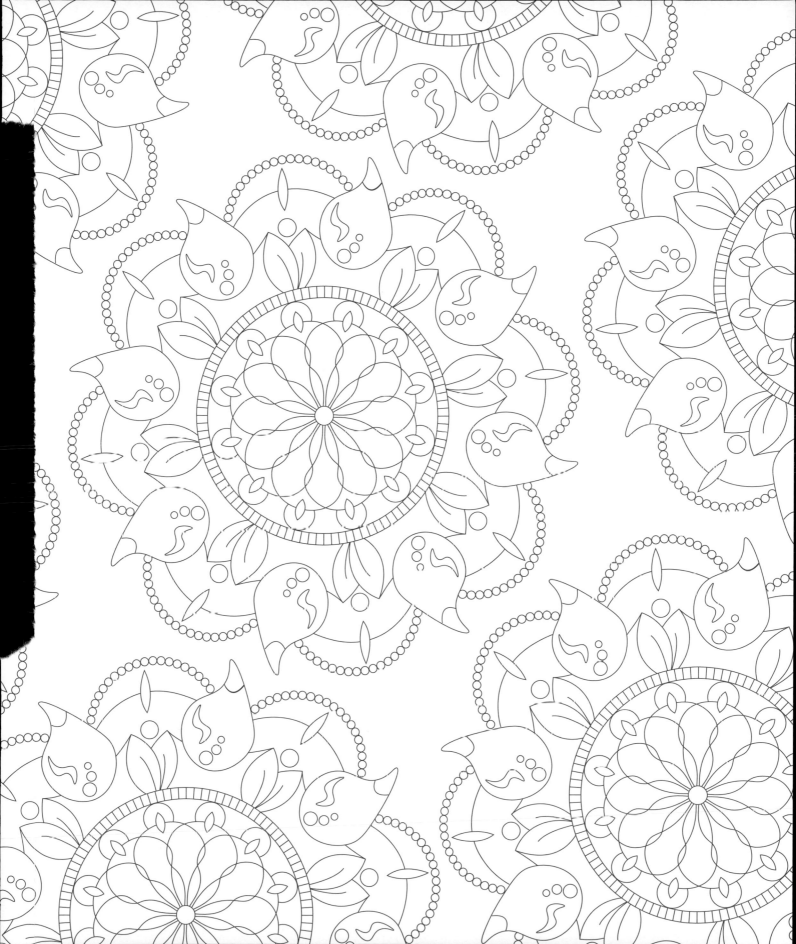

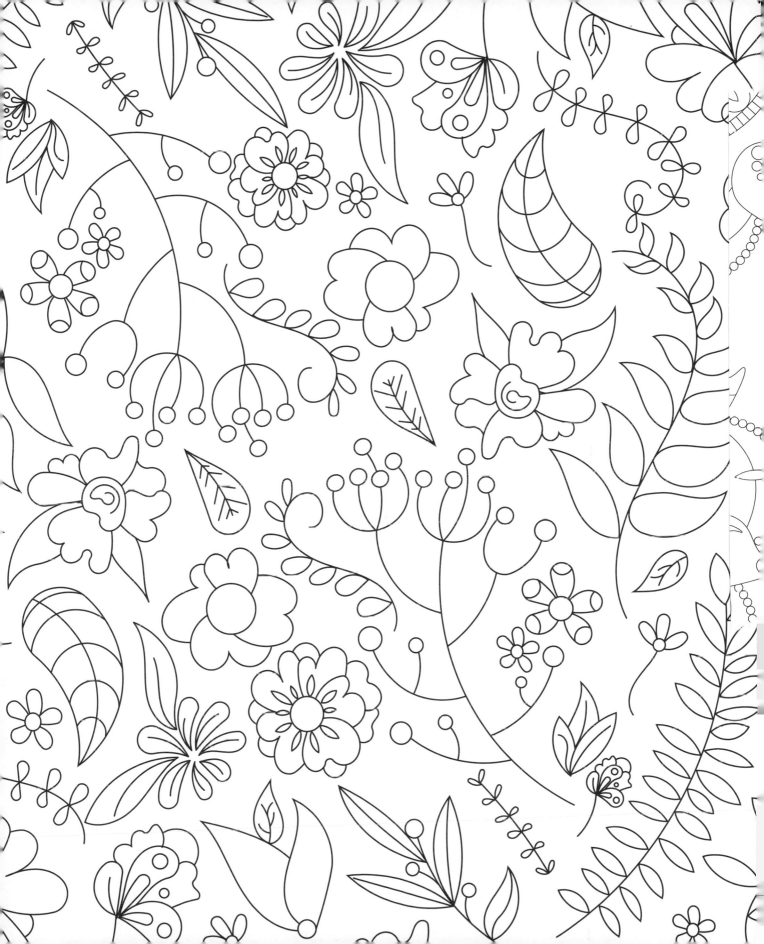

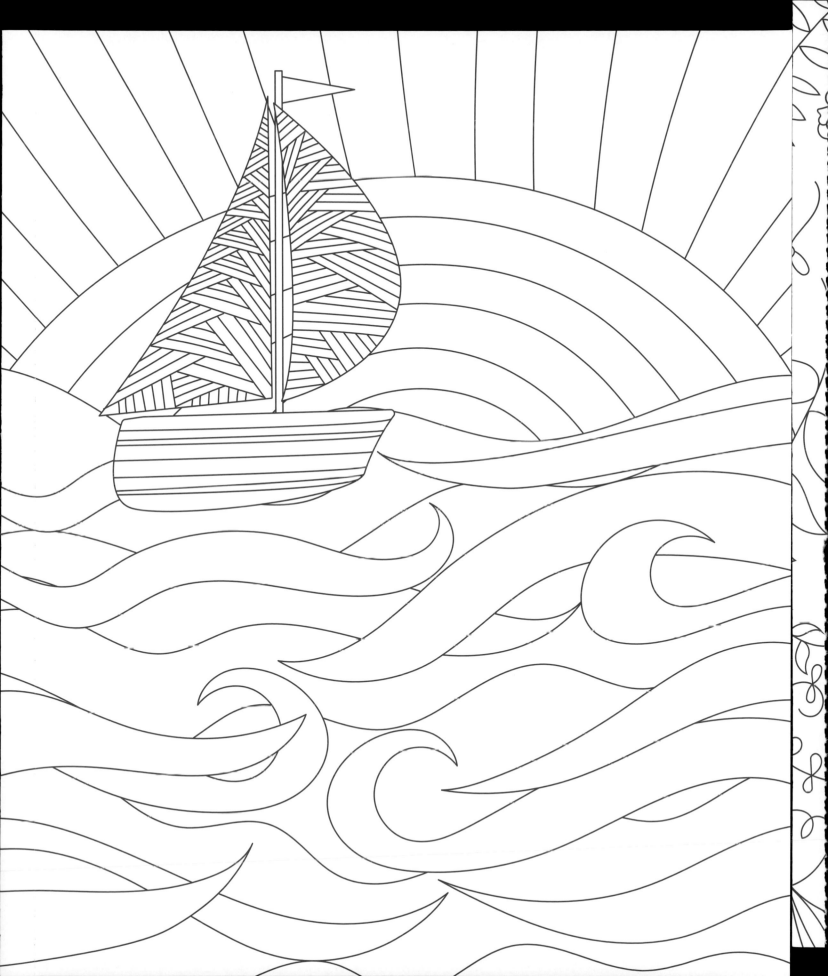

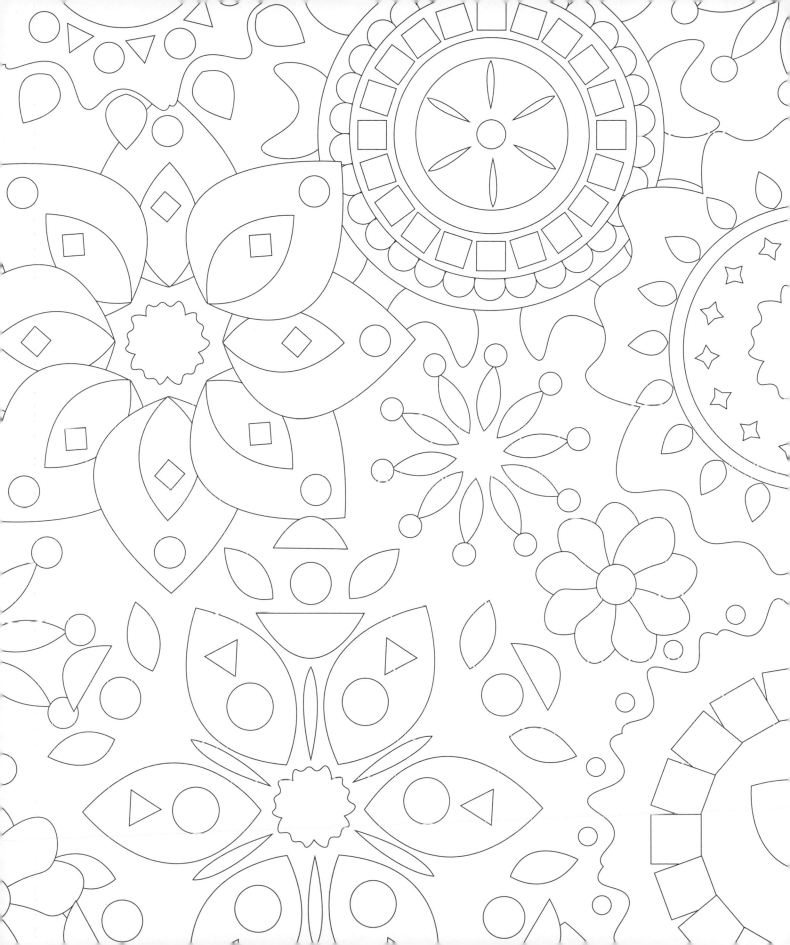

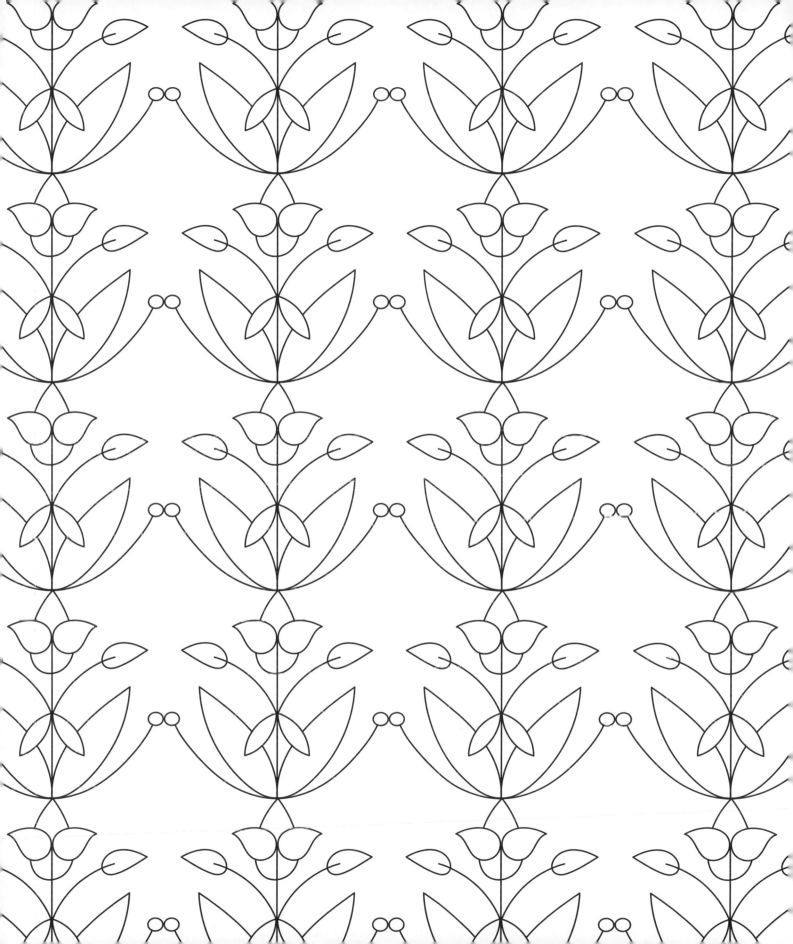

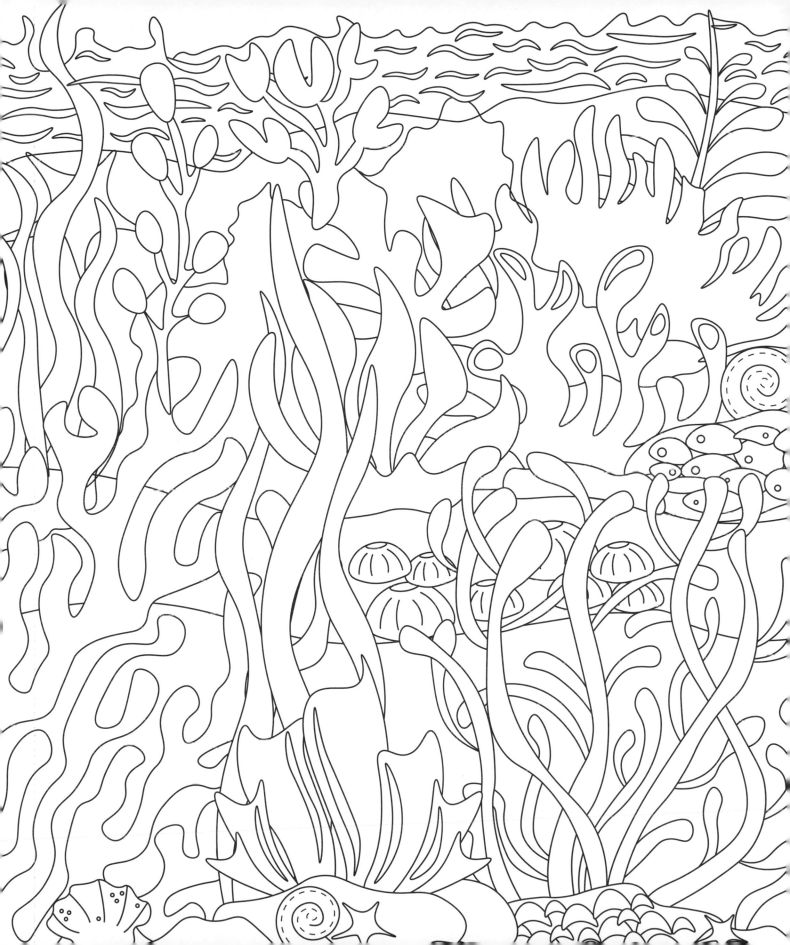

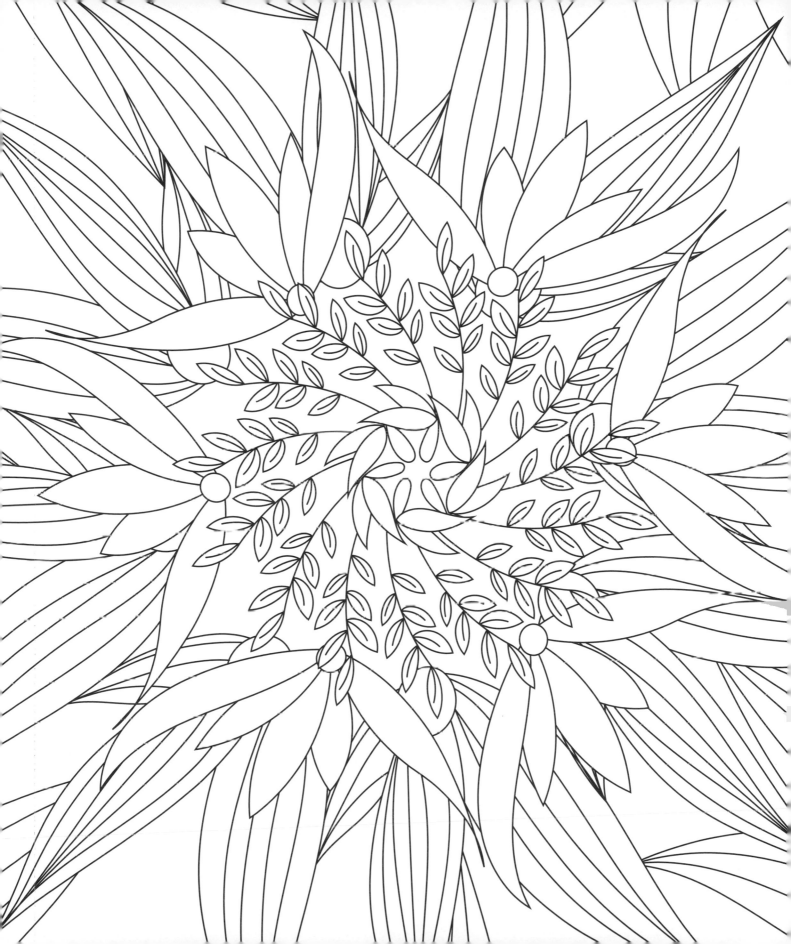

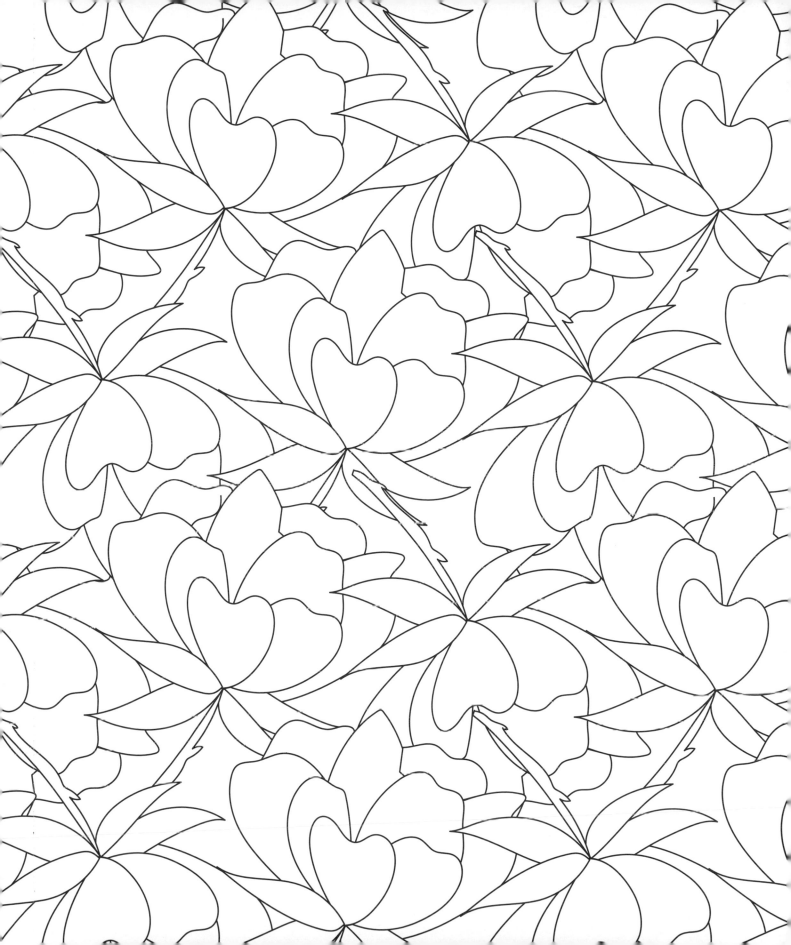

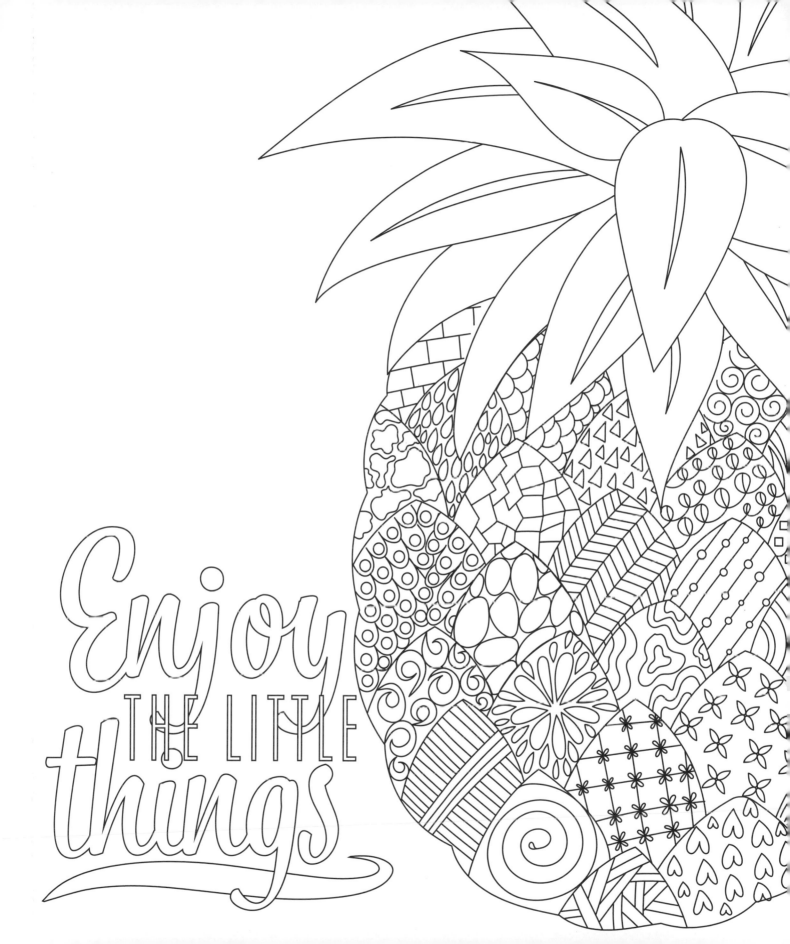

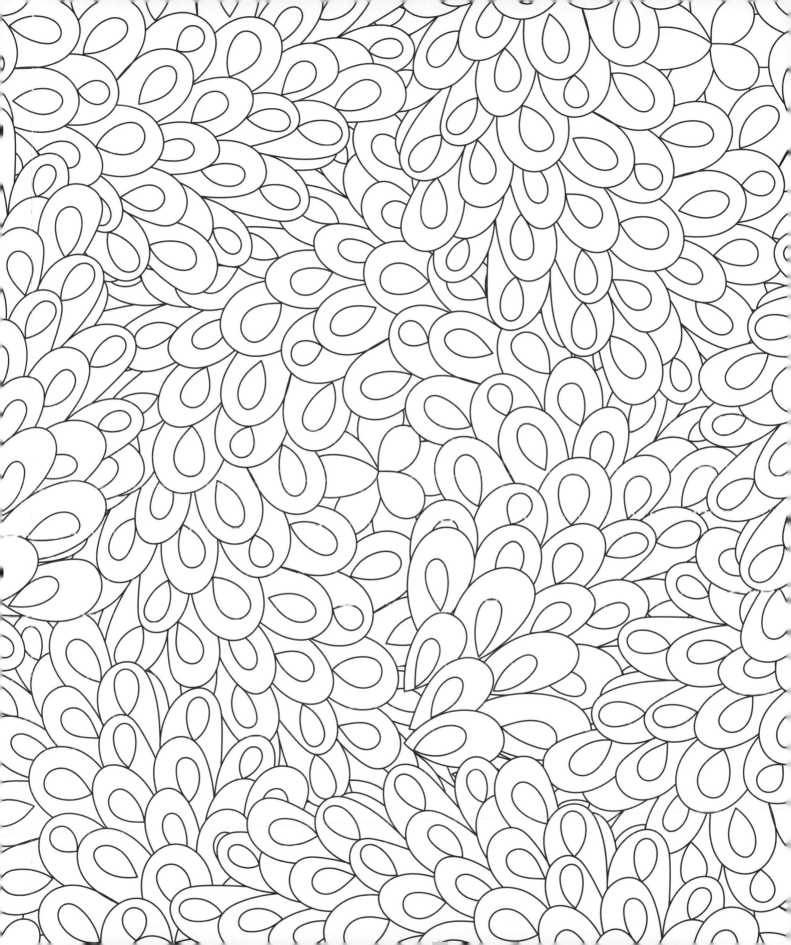

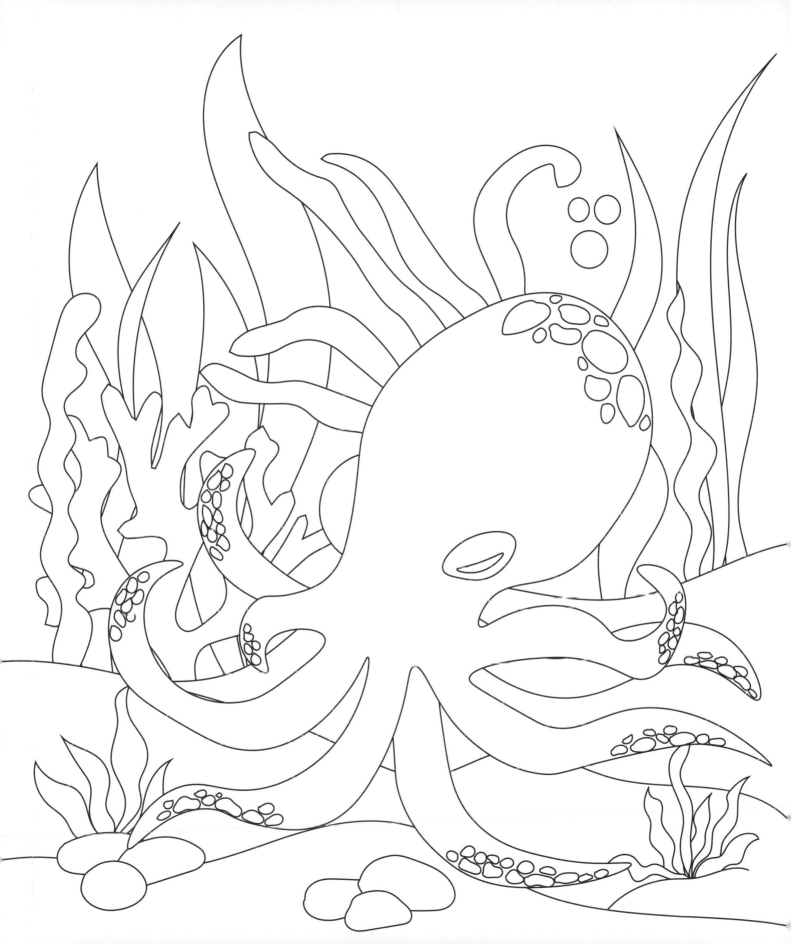

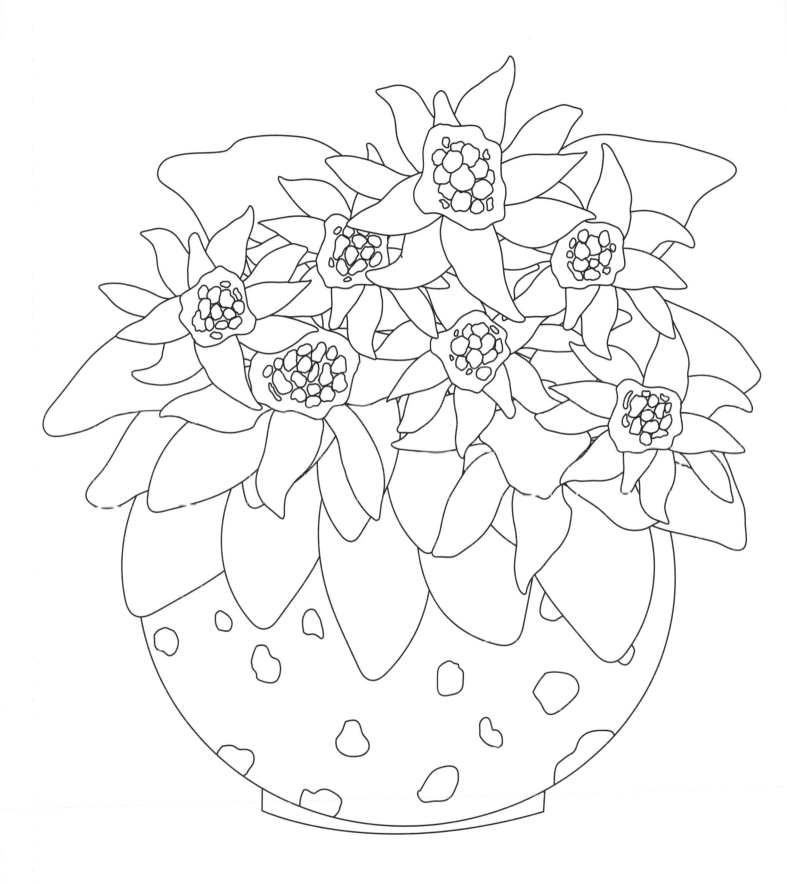

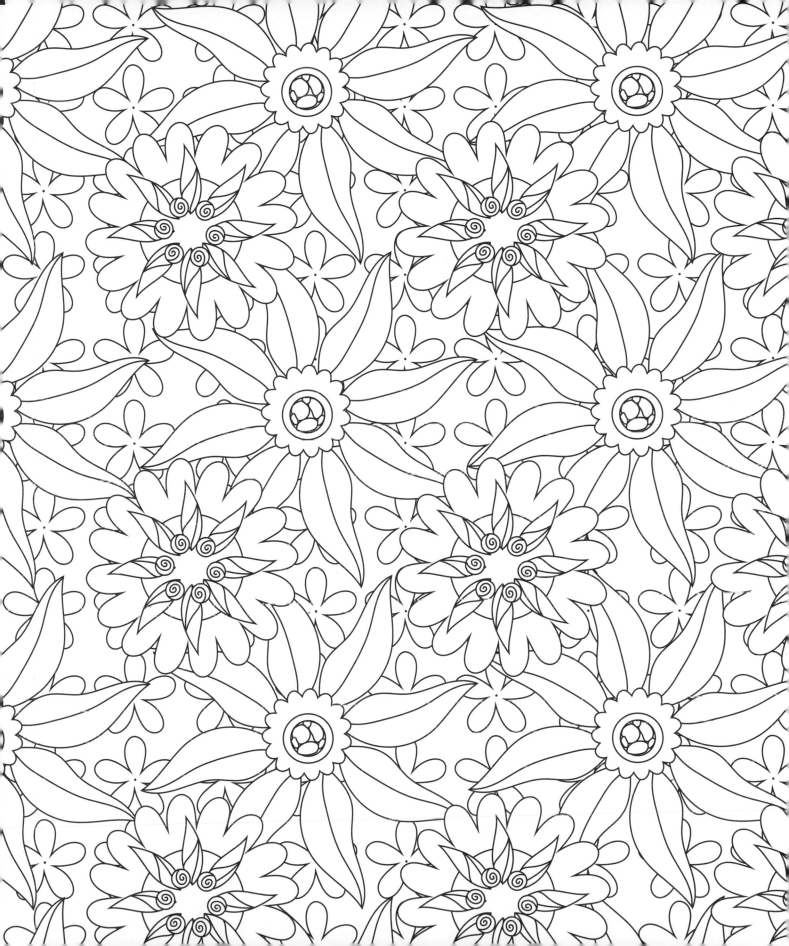

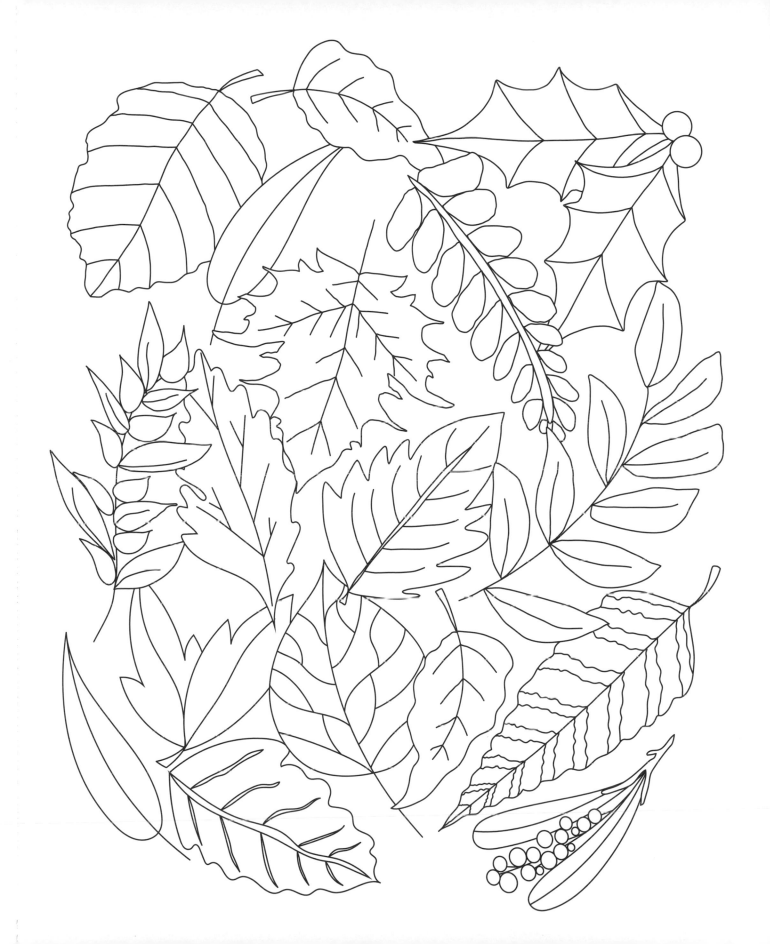

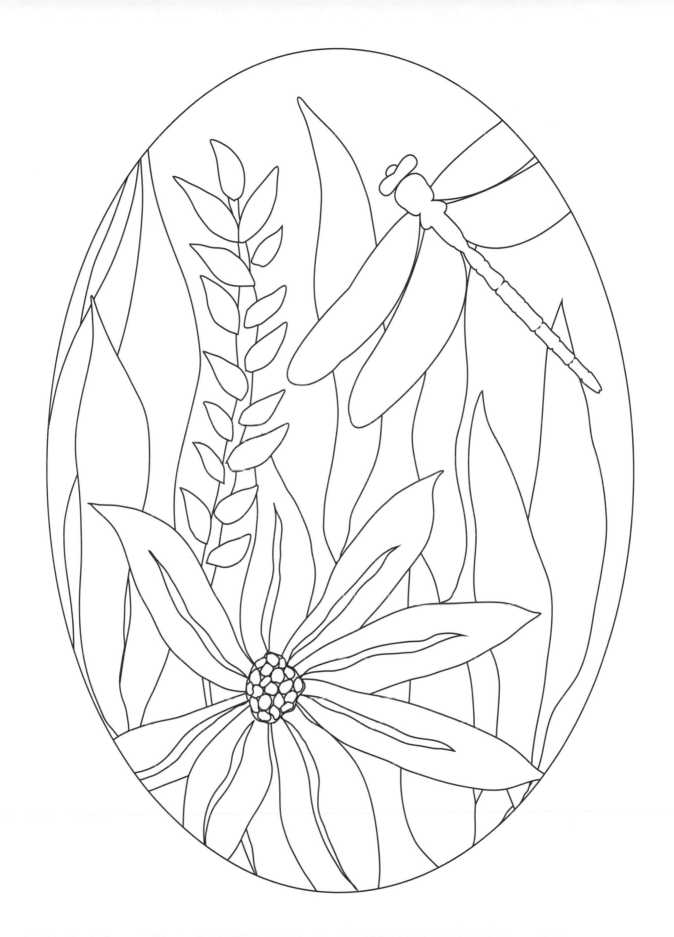

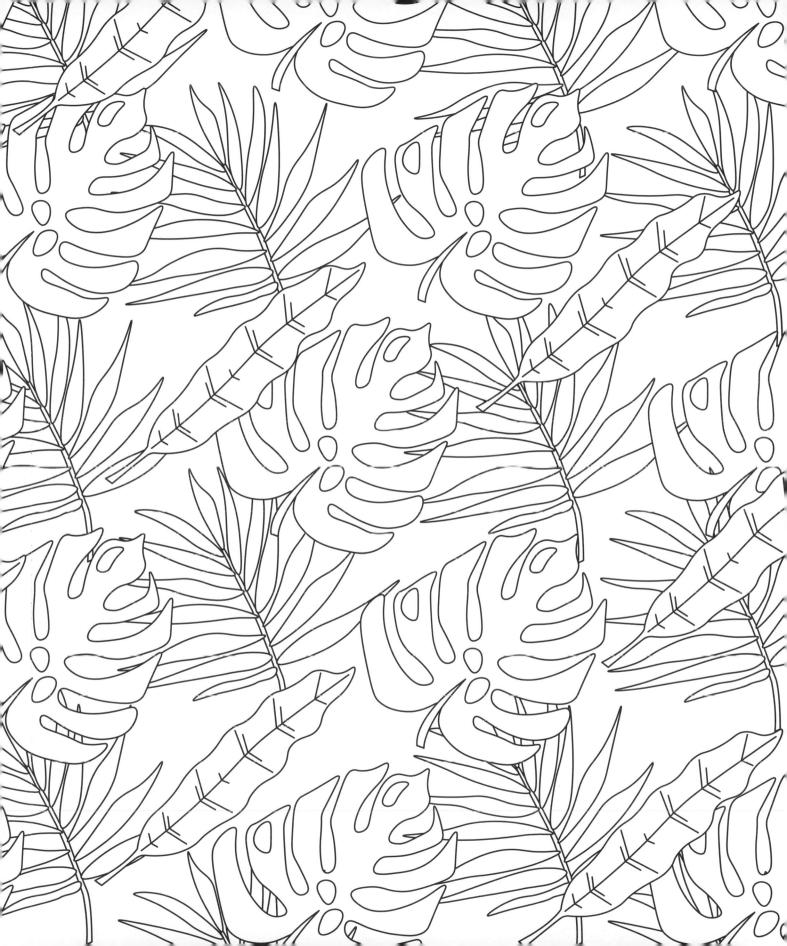

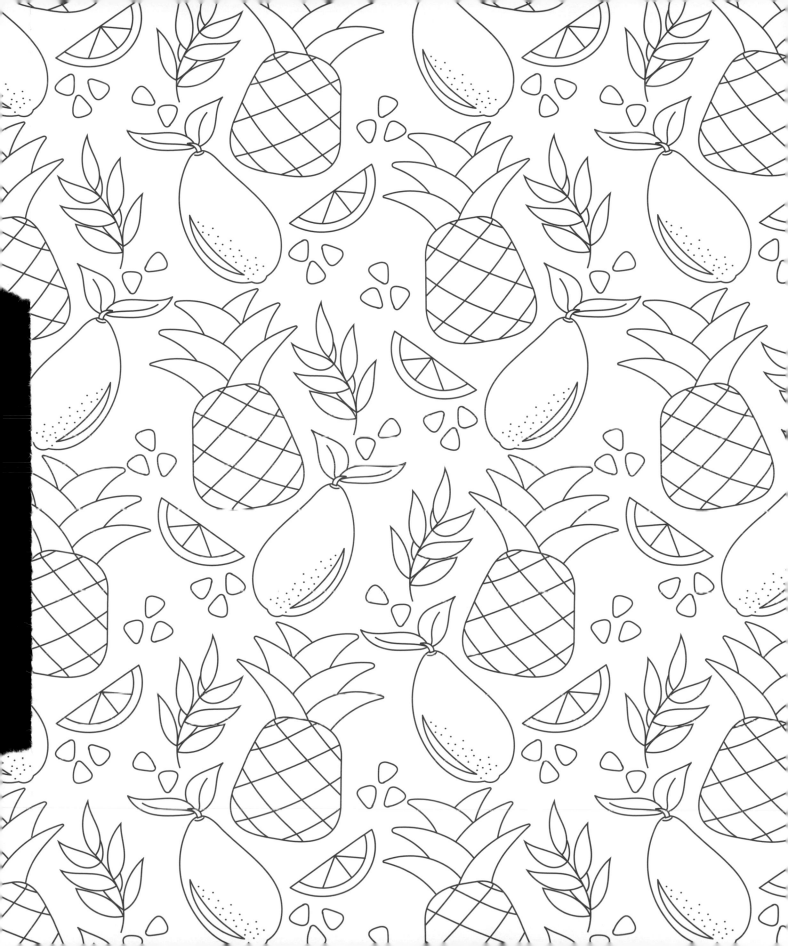